SIERRA

Engagement Calendar
2011

MW00681479

SIERRA CLUB • CROWN PUBLISHERS

The Sierra Club, founded in 1892 by author and conservationist John Muir, is the oldest, largest, and most influential grassroots environmental organization in the United States. With more than a million members and supporters—and some sixty chapters across the country—we are working hard to protect our local communities, ensure an enduring legacy for America's wild places, and find smart energy solutions to stop global warming. To learn how you can participate in the Sierra Club's programs to explore, enjoy, and protect the planet, please address inquiries to Sierra Club, 85 Second Street, San Francisco, California 94105, or visit our website at www.sierraclub.org.

Astronomical information is given in eastern standard time.

Eclipses noted are visible from North America.

This calendar was printed in Italy by A. Mondadori Editore, S.p.A., Verona. Distribution is by Crown Publishers, a division of Random House, Inc., New York, New York.

Persons interested in obtaining individual photographs in this calendar should address inquiries to the photographer credited in the caption, in care of Sierra Club Books, 85 Second Street, San Francisco, California 94105; all letters will be forwarded.

The interior of this Sierra Club calendar is printed on paper containing a minimum of 50% recovered waste, of which at least 10% of the fiber content is postconsumer waste. The virgin component of the paper is chlorine free and entirely from tree farms.

PHOTO EDITORS: SCOTT ATKINSON, HELEN SWEETLAND
PRINTING CONSULTANT: NANETTE STEVENSON
DIGITAL IMAGE PRODUCTION: PREPRESS INC., SAN FRANCISCO
EDITORIAL PRODUCTION: KATE KENNEDY, NATALIE MANSFIELD
DESIGN: BARBARA MARKS

Front cover:
Flowering dogwood above Little River, Great Smoky Mountains National Park, Tennessee.
PHOTO: MARY LIZ AUSTIN

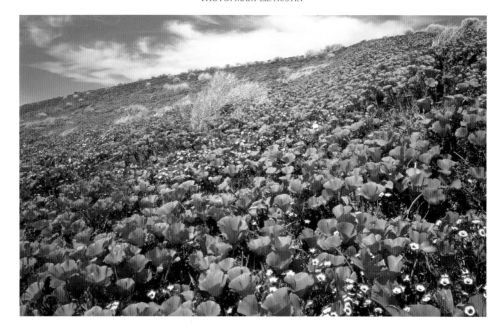

California poppies, Antelope Valley California Poppy Reserve, California.
PHOTO: JACK DYKINGA

Sierra Club: A Youthful Passion to Explore, Enjoy and Protect the Planet

L ucky John Muir. The rhapsodic Scotsman spent his youth "botanizing in glorious freedom around the Great Lakes" and traipsing across mountain glaciers—not to mention scaling a Douglas fir to let a raging Sierra windstorm whipsaw him "like a bobo-link on a reed." By the time he arrived in the Sierra, he had hiked from the middle of the Mississippi Valley to the Gulf of Mexico, sailed to Cuba, and crossed the Isthmus of Panama. The young man loved adventure.

In a time when some people actually believed that flooding one of the most beautiful valleys in the brand-new Yosemite National Park was a good idea, Muir saw irreplaceable value in nature's most beautiful playgrounds. He devoted himself to conveying the importance of conserving these natural sanctuaries, and the club he founded—the Sierra Club—has worked to protect wild places, open spaces, air, and water for more than a century.

When I arrived at the Sierra Club as an intern for *Sierra* magazine, I wasn't sure how the organization's motto—"Explore, Enjoy and Protect the Planet"—fit together. I knew Muir mainly as the wild-bearded icon who had led the fight to create America's national parks. Soon enough I realized that Muir's youth had forged his determination—that he, like me and so many of my friends, had explored the raw natural world and so enjoyed its icy mountains and pounding rivers that protecting such places became a passion.

Now, as the planet faces perils Muir couldn't have imagined, it's important to me and my generation to know we can join together in—indeed, that

we can help lead—an organization with 119 years of success in solving the world's environmental problems.

Our Sierra Club has led the charge in protecting more than 250 million acres of wild lands and 11,000 miles of wild and scenic rivers across the United States. We were instrumental in passing the Clean Water Act, the Clean Air Act, and the Endangered Species Act. And as new threats to the planet arise—like the potential devastation of climate change and the atmosphere-damaging pollution caused by burning coal—we continue to use the power of public education, political accountability, and grassroots organizing to guide the United States toward a prosperous clean-energy future, fueled by green jobs.

But perhaps the work Muir would find most important, and still the best tool we have for protecting the planet, is developing passion for the natural world. Through our Inner City Outings program, 12,000 young people who may never have visited a forest, mountain, or river join our enthusiastic experts on

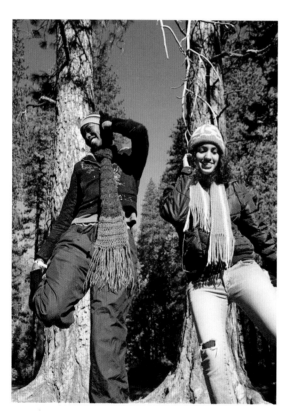

Yosemite inspires dance moves for Los Angeles students in a Sierra Club program called Building Bridges to the Outdoors. PHOTO: MICHAEL WINOKUR

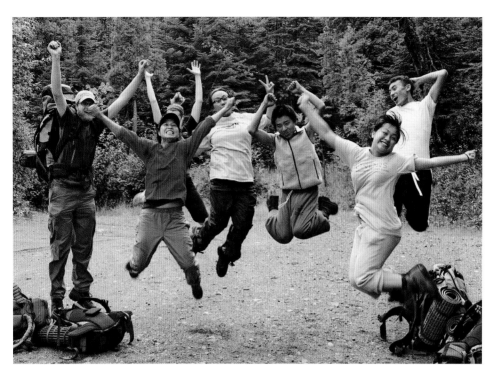

Students from Sierra Club's Inner City Outings program leap at the chance to backpack in Minnesota. PHOTO: COURTESY OF MINNESOTA INNER CITY OUTINGS

wilderness trips and service projects every year. Our Building Bridges to the Outdoors program also fights "nature deficit disorder" by working with a diverse coalition of partners to give every child a chance to experience the outdoors firsthand.

The Sierra Club was a hiking club before it was a political force, and it's our hope that future generations of adventurers will have the opportunity to learn respect for the environment in the same way Muir did: by sliding across glaciers, hiking through waist-high wildflowers, and maybe even swaying in wind-whipped treetops.

—Sarah Kessler, *Sierra* magazine intern and
student at Northwestern University, class of 2010

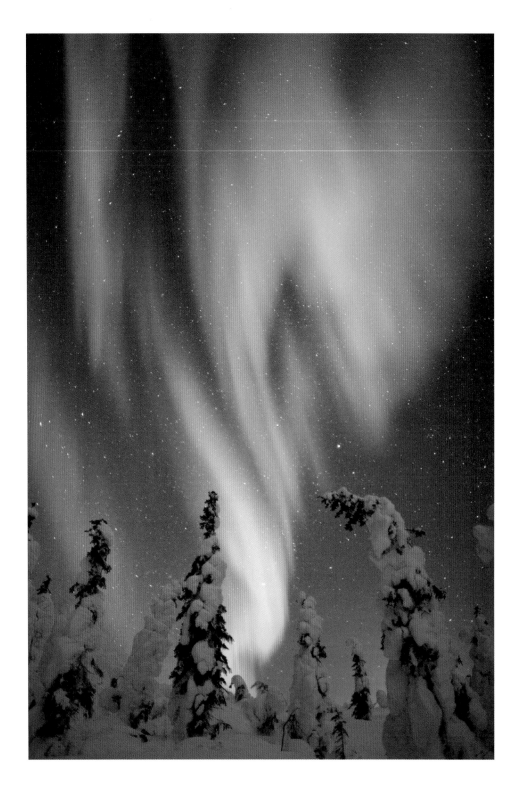

Aurora borealis over snow-covered spruce trees, interior Alaska.
PHOTO: PATRICK J. ENDRES

JANUARY

S	M	T	W	T	F	S
						1
2	3	4	5	6	7	8
9	10	11	12	13	14	15
16	17	18	19	20	21	22
23	24	25	26	27	28	29
30	31					

December
January

MONDAY 27

TUESDAY 28

WEDNESDAY 29

THURSDAY 30

FRIDAY 31

SATURDAY 1

New Year's Day

SUNDAY 2

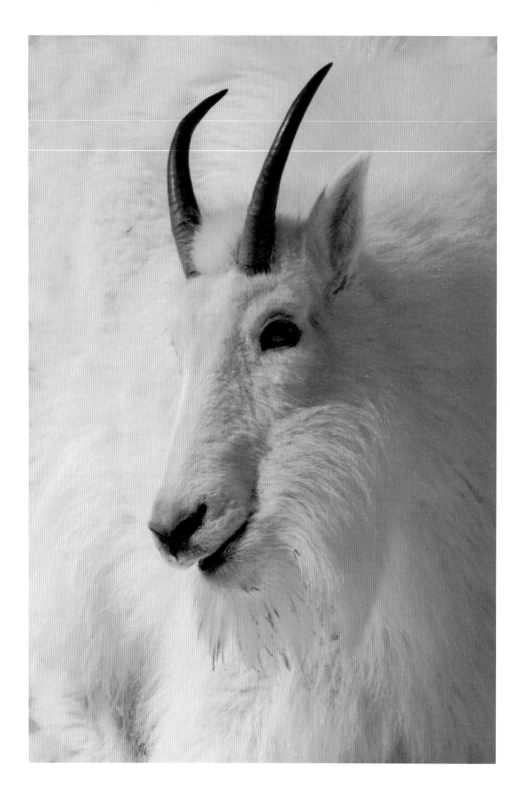

Mountain goat, Snake River Canyon, Caribou–Targhee National Forest, Wyoming.
PHOTO: IRENE F. GREENBERG

JANUARY

S	M	T	W	T	F	S
						1
2	3	4	5	6	7	8
9	10	11	12	13	14	15
16	17	18	19	20	21	22
23	24	25	26	27	28	29
30	31					

January

MONDAY 3

TUESDAY 4

● NEW MOON

WEDNESDAY 5

THURSDAY 6

FRIDAY 7

SATURDAY 8

SUNDAY 9

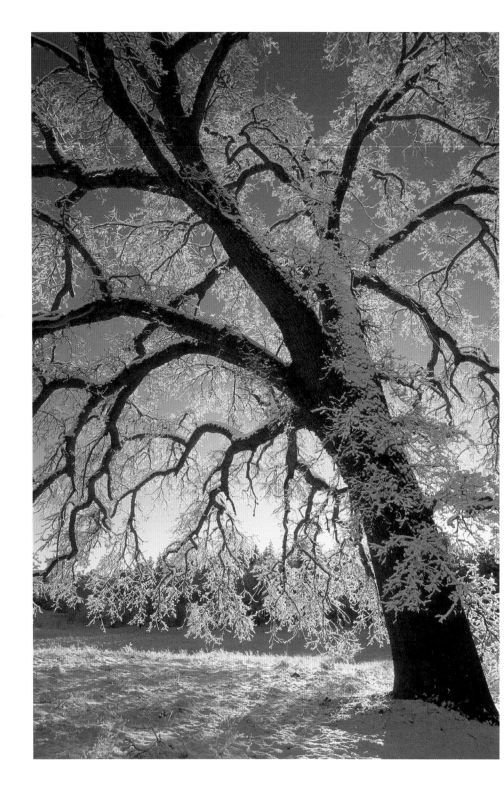

Black oak in winter, Groveland, California.
PHOTO: ROBB HIRSCH

JANUARY

S	M	T	W	T	F	S
						1
2	3	4	5	6	7	8
9	10	11	12	13	14	15
16	17	18	19	20	21	22
23	24	25	26	27	28	29
30	31					

January

MONDAY 10

TUESDAY 11

WEDNESDAY 12

◑ FIRST QUARTER

THURSDAY 13

FRIDAY 14

SATURDAY 15

SUNDAY 16

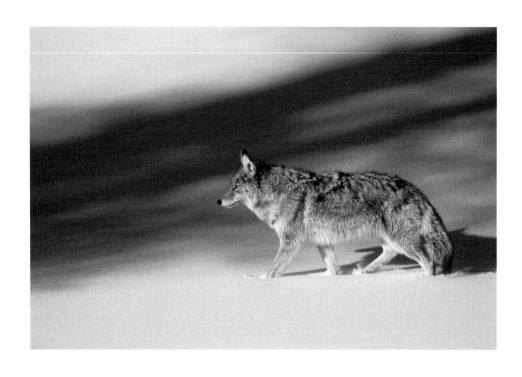

Coyote, Yellowstone National Park, Wyoming.
PHOTO: DAVE WELLING

JANUARY

S	M	T	W	T	F	S
						1
2	3	4	5	6	7	8
9	10	11	12	13	14	15
16	17	18	19	20	21	22
23	24	25	26	27	28	29
30	31					

January

MONDAY 17

Martin Luther King Jr.'s birthday (observed)

TUESDAY 18

WEDNESDAY 19

○ FULL MOON

THURSDAY 20

FRIDAY 21

SATURDAY 22

SUNDAY 23

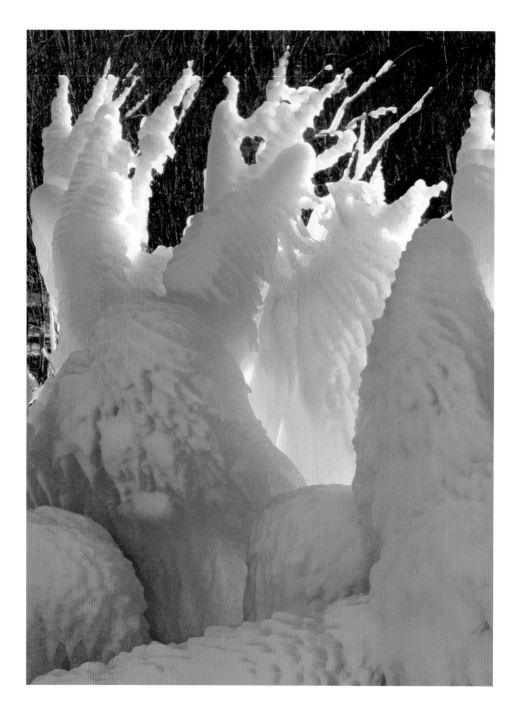

Wind-sculpted ice formations, Columbia River Gorge National Scenic Area, Oregon.
PHOTO: STEVE TERRILL

JANUARY

S	M	T	W	T	F	S
						1
2	3	4	5	6	7	8
9	10	11	12	13	14	15
16	17	18	19	20	21	22
23	24	25	26	27	28	29
30	31					

January

MONDAY 24

TUESDAY 25

WEDNESDAY 26

◑ LAST QUARTER

THURSDAY 27

FRIDAY 28

SATURDAY 29

SUNDAY 30

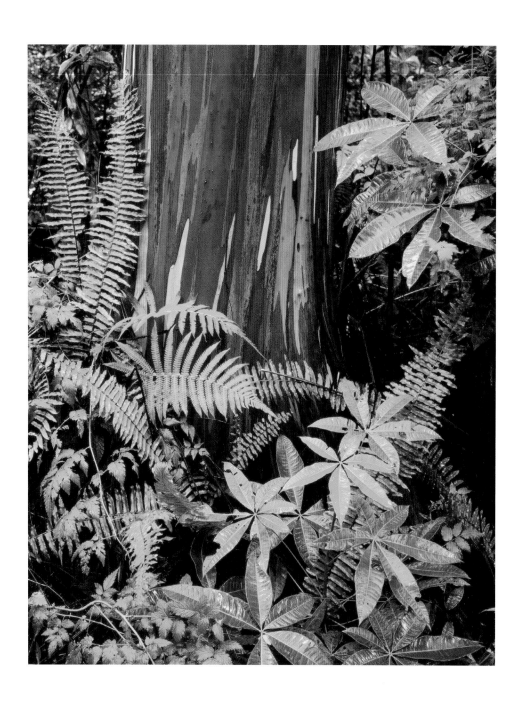

Ferns against painted bark eucalyptus trunk, Ke`anae Arboretum, Maui, Hawai`i.
PHOTO: JOHN HENDRICKSON

FEBRUARY

S	M	T	W	T	F	S
		1	2	3	4	5
6	7	8	9	10	11	12
13	14	15	16	17	18	19
20	21	22	23	24	25	26
27	28					

January
February

MONDAY *31*

TUESDAY *1*

WEDNESDAY *2*

● NEW MOON

THURSDAY *3*

FRIDAY *4*

SATURDAY *5*

SUNDAY *6*

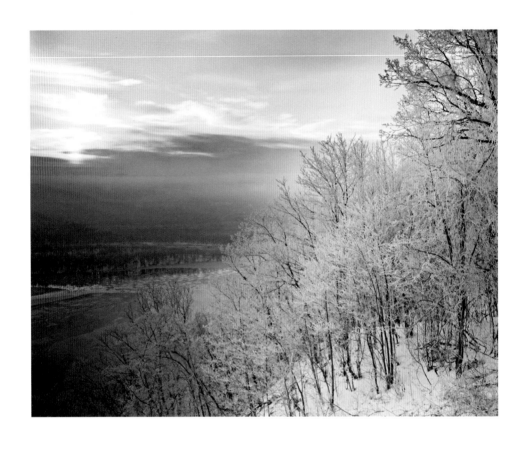

Icy trees at dawn, Upper Mississippi River National Wildlife and Fish Refuge, Iowa.
PHOTO: TOM TILL

FEBRUARY

S	M	T	W	T	F	S
		1	2	3	4	5
6	7	8	9	10	11	12
13	14	15	16	17	18	19
20	21	22	23	24	25	26
27	28					

February

MONDAY *7*

TUESDAY *8*

WEDNESDAY *9*

THURSDAY *10*

FRIDAY *11*

◑ FIRST QUARTER

SATURDAY *12*

SUNDAY *13*

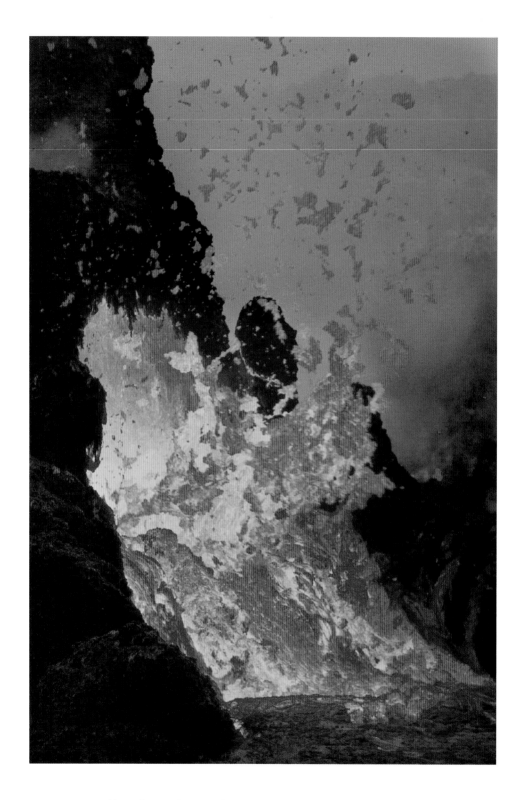

Spatter cone and lava flow, Kilauea Volcano, Hawai`i Volcanoes National Park, Hawai`i.
PHOTO: G. BRAD LEWIS/LARRY ULRICH STOCK

FEBRUARY						
S	M	T	W	T	F	S
		1	2	3	4	5
6	7	8	9	10	11	12
13	14	15	16	17	18	19
20	21	22	23	24	25	26
27	28					

February

MONDAY *14*

Valentine's Day

TUESDAY *15*

WEDNESDAY *16*

THURSDAY *17*

FRIDAY *18*

○ FULL MOON

SATURDAY *19*

SUNDAY *20*

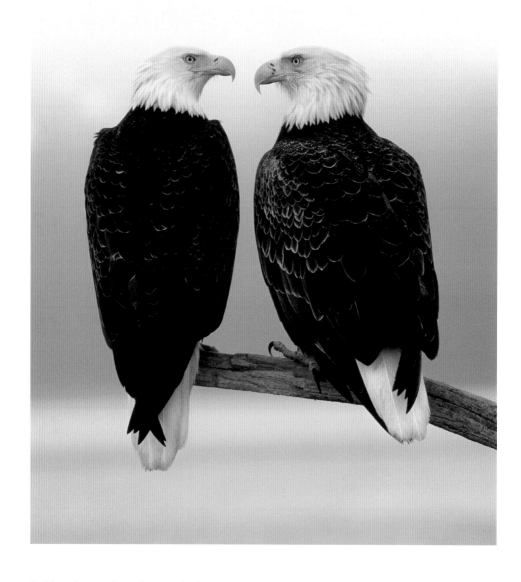

Bald eagles, Kachemak Bay, Alaska.
PHOTO: THOMAS D. MANGELSEN

FEBRUARY

S	M	T	W	T	F	S
		1	2	3	4	5
6	7	8	9	10	11	12
13	14	15	16	17	18	19
20	21	22	23	24	25	26
27	28					

February

MONDAY *21*

Presidents Day

TUESDAY *22*

WEDNESDAY *23*

THURSDAY *24*

◑ LAST QUARTER

FRIDAY *25*

SATURDAY *26*

SUNDAY *27*

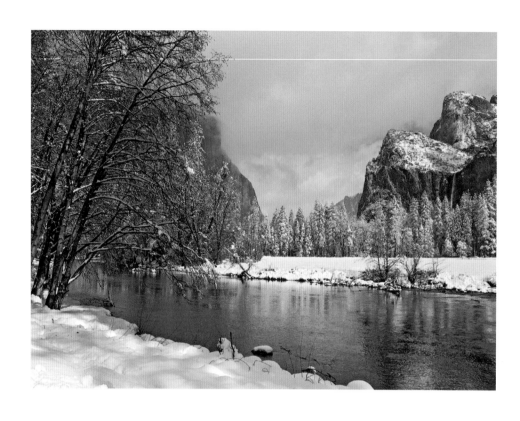

Bridalveil Fall and Merced River, Yosemite National Park, California.
PHOTO: LORY HAWLEY

			MARCH			
S	M	T	W	T	F	S
		1	2	3	4	5
6	7	8	9	10	11	12
13	14	15	16	17	18	19
20	21	22	23	24	25	26
27	28	29	30	31		

February
March

MONDAY *28*

TUESDAY *1*

WEDNESDAY *2*

THURSDAY *3*

FRIDAY *4*

● NEW MOON

SATURDAY *5*

SUNDAY *6*

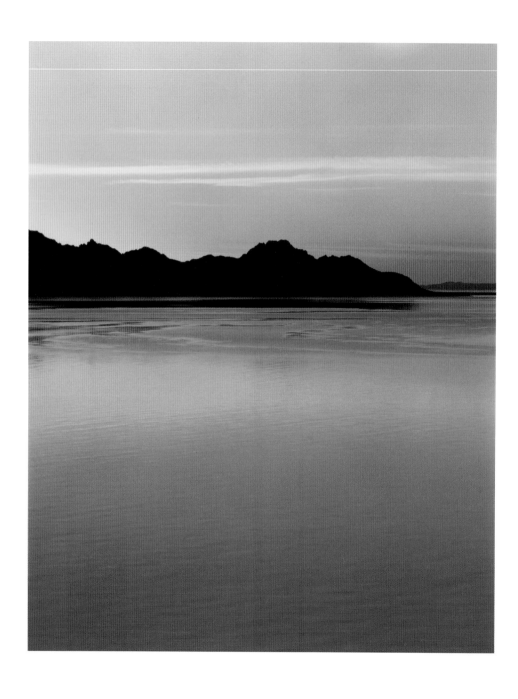

Dawn over the Sea of Cortez, Isla del Carmen, Baja California, Mexico.
PHOTO: STEPHEN K. HALL

MARCH

S	M	T	W	T	F	S
		1	2	3	4	5
6	7	8	9	10	11	12
13	14	15	16	17	18	19
20	21	22	23	24	25	26
27	28	29	30	31		

March

MONDAY *7*

TUESDAY *8*

WEDNESDAY *9*

Ash Wednesday

THURSDAY *10*

FRIDAY *11*

SATURDAY *12*

◖ FIRST QUARTER

SUNDAY *13*

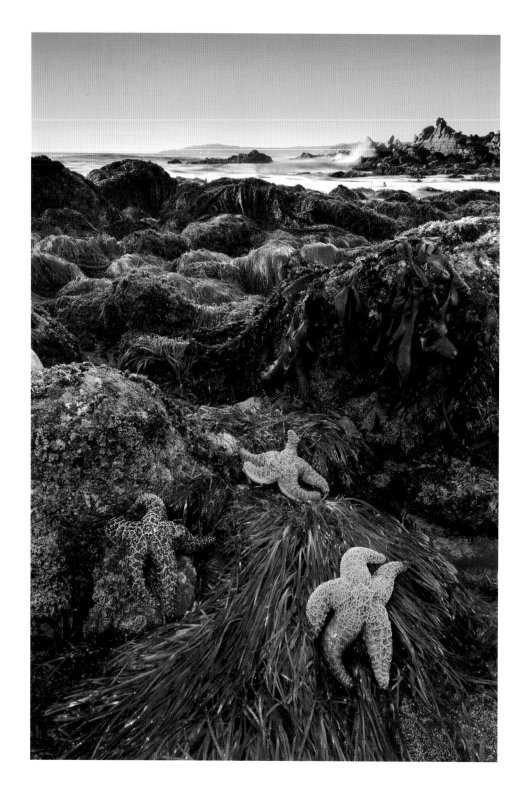

Starfish at low tide, Carmel Point, Carmel, California.
PHOTO: DOUGLAS STEAKLEY

	MARCH					
S	M	T	W	T	F	S
		1	2	3	4	5
6	7	8	9	10	11	12
13	14	15	16	17	18	19
20	21	22	23	24	25	26
27	28	29	30	31		

March

MONDAY *14*

TUESDAY *15*

WEDNESDAY *16*

THURSDAY *17*

St. Patrick's Day

FRIDAY *18*

SATURDAY *19*

○ FULL MOON

SUNDAY *20*

EQUINOX

Poppy, Brookside Gardens in Wheaton Regional Park, Montgomery County, Maryland.
PHOTO: TONY SWEET

MARCH

S	M	T	W	T	F	S
		1	2	3	4	5
6	7	8	9	10	11	12
13	14	15	16	17	18	19
20	21	22	23	24	25	26
27	28	29	30	31		

March

MONDAY *21*

TUESDAY *22*

WEDNESDAY *23*

THURSDAY *24*

FRIDAY *25*

SATURDAY *26*

◑ LAST QUARTER

SUNDAY *27*

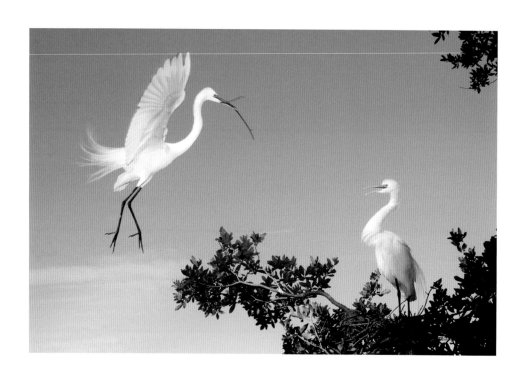

Great egrets, St. Augustine Alligator Farm, St. Augustine, Florida.
PHOTO: PATRICK DENNEN

APRIL

S	M	T	W	T	F	S
					1	2
3	4	5	6	7	8	9
10	11	12	13	14	15	16
17	18	19	20	21	22	23
24	25	26	27	28	29	30

March
April

MONDAY *28*

TUESDAY *29*

WEDNESDAY *30*

THURSDAY *31*

FRIDAY *1*

SATURDAY *2*

SUNDAY *3*

● NEW MOON

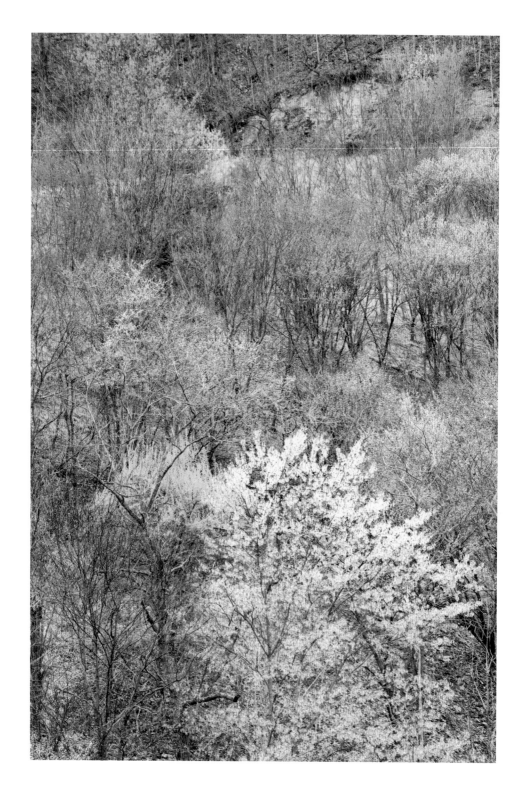

Redbud trees, Pike County, Kentucky.
PHOTO: CHUCK SUMMERS

APRIL

S	M	T	W	T	F	S
					1	2
3	4	5	6	7	8	9
10	11	12	13	14	15	16
17	18	19	20	21	22	23
24	25	26	27	28	29	30

April

MONDAY 4

TUESDAY 5

WEDNESDAY 6

THURSDAY 7

FRIDAY 8

SATURDAY 9

SUNDAY 10

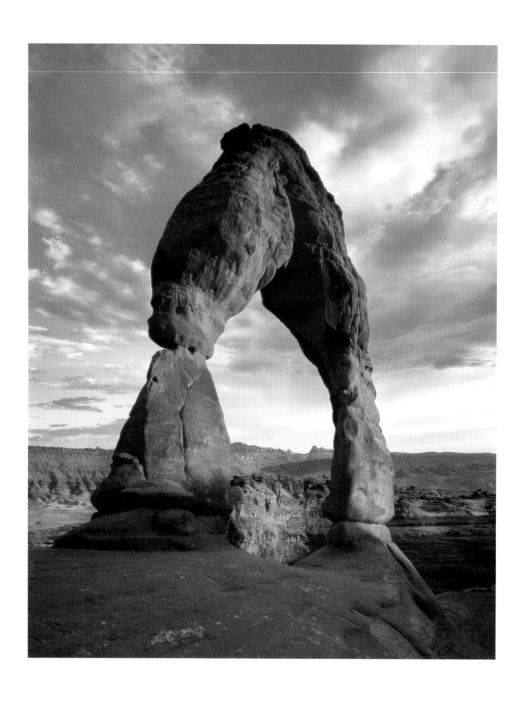

Delicate Arch in late afternoon, Arches National Park, Utah.
PHOTO: RANDY PRENTICE

APRIL

S	M	T	W	T	F	S
					1	2
3	4	5	6	7	8	9
10	11	12	13	14	15	16
17	18	19	20	21	22	23
24	25	26	27	28	29	30

April

MONDAY *11*

◑ FIRST QUARTER

TUESDAY *12*

WEDNESDAY *13*

THURSDAY *14*

FRIDAY *15*

SATURDAY *16*

SUNDAY *17*

Palm Sunday
○ FULL MOON

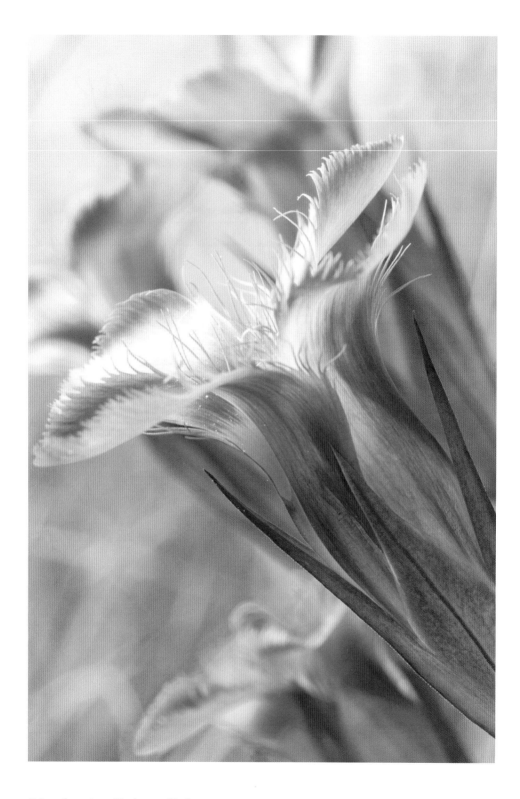

Fringed gentian, Clarkston, Michigan.
PHOTO: PATRICK DENNEN

APRIL

S	M	T	W	T	F	S
					1	2
3	4	5	6	7	8	9
10	11	12	13	14	15	16
17	18	19	20	21	22	23
24	25	26	27	28	29	30

April

MONDAY *18*

TUESDAY *19*

Passover

WEDNESDAY *20*

THURSDAY *21*

John Muir's birthday

FRIDAY *22*

Good Friday
Earth Day

SATURDAY *23*

SUNDAY *24*

Easter
◑ LAST QUARTER

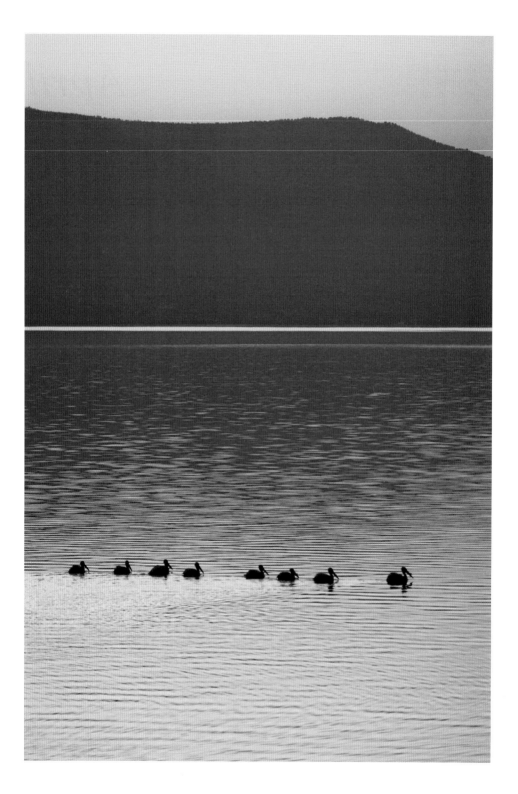

American white pelicans, Bear Lake, Idaho.
PHOTO: SCOTT T. SMITH

MAY

S	M	T	W	T	F	S
1	2	3	4	5	6	7
8	9	10	11	12	13	14
15	16	17	18	19	20	21
22	23	24	25	26	27	28
29	30	31				

April
May

MONDAY *25*

TUESDAY *26*

WEDNESDAY *27*

THURSDAY *28*

FRIDAY *29*

SATURDAY *30*

SUNDAY *1*

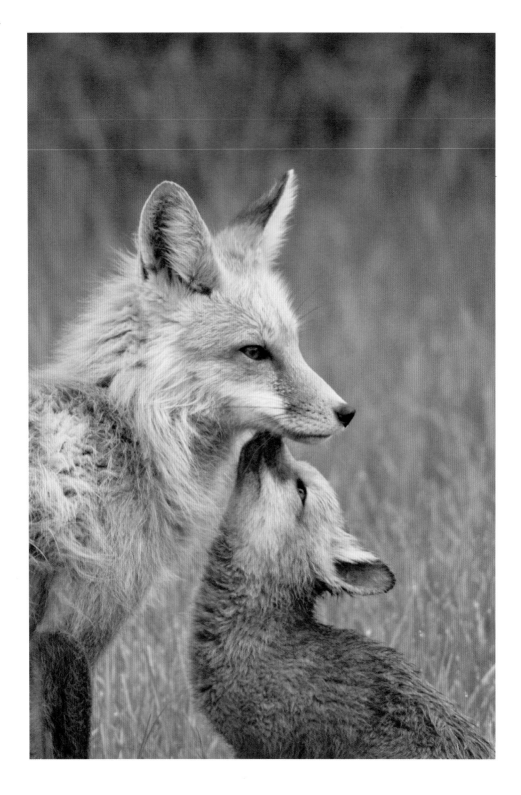

Red fox vixen and kit, Jackson, Wyoming.
PHOTO: IRENE F. GREENBERG

MAY

S	M	T	W	T	F	S
1	2	3	4	5	6	7
8	9	10	11	12	13	14
15	16	17	18	19	20	21
22	23	24	25	26	27	28
29	30	31				

May

MONDAY *2*

TUESDAY *3*

● NEW MOON

WEDNESDAY *4*

THURSDAY *5*

FRIDAY *6*

SATURDAY *7*

SUNDAY *8*

Mother's Day

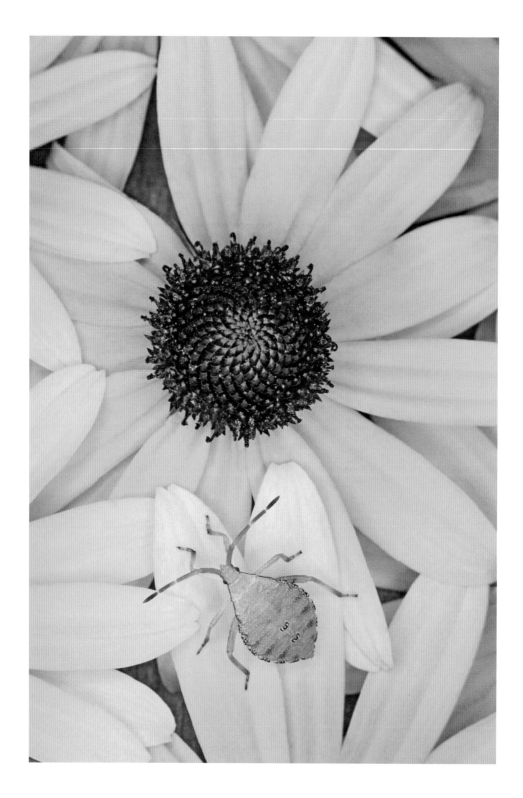

Green stinkbug on black-eyed Susan, Berea, Ohio.
PHOTO: BILL BEATTY

MAY

S	M	T	W	T	F	S
1	2	3	4	5	6	7
8	9	10	11	12	13	14
15	16	17	18	19	20	21
22	23	24	25	26	27	28
29	30	31				

May

MONDAY *9*

TUESDAY *10*

◑ FIRST QUARTER

WEDNESDAY *11*

THURSDAY *12*

FRIDAY *13*

SATURDAY *14*

SUNDAY *15*

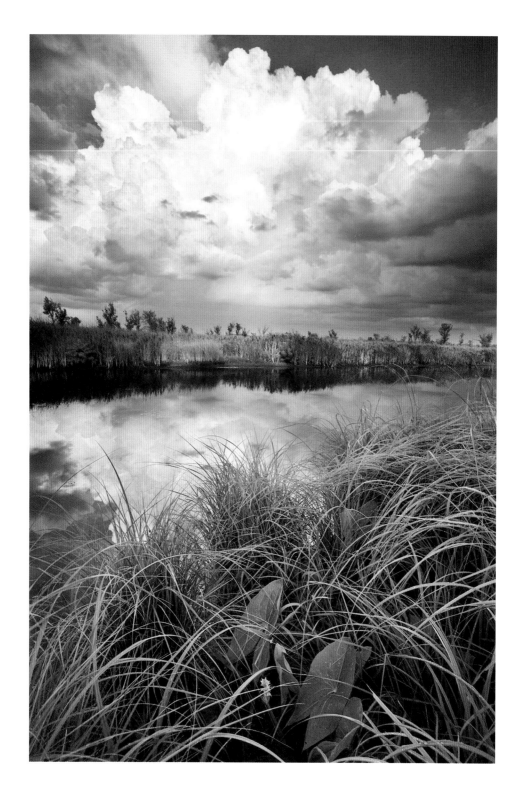

Arrowroot and storm clouds, Haskell-Baker Wetlands, Kansas.
PHOTO: EDWARD C. ROBISON III

MAY

S	M	T	W	T	F	S
1	2	3	4	5	6	7
8	9	10	11	12	13	14
15	16	17	18	19	20	21
22	23	24	25	26	27	28
29	30	31				

May

MONDAY *16*

TUESDAY *17*

○ FULL MOON

WEDNESDAY *18*

THURSDAY *19*

FRIDAY *20*

SATURDAY *21*

SUNDAY *22*

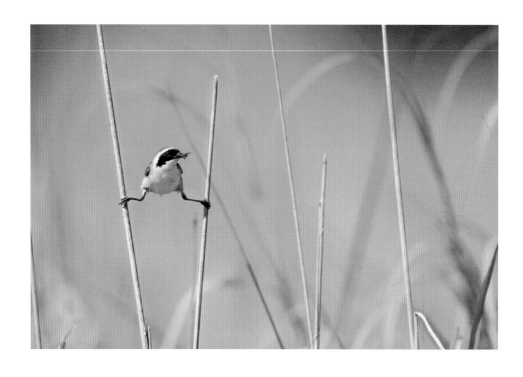

Common yellowthroat in prairie, Marion County, Illinois.

MAY

S	M	T	W	T	F	S
1	2	3	4	5	6	7
8	9	10	11	12	13	14
15	16	17	18	19	20	21
22	23	24	25	26	27	28
29	30	31				

May

MONDAY *23*

Victoria Day (Canada)

TUESDAY *24*

◑ LAST QUARTER

WEDNESDAY *25*

THURSDAY *26*

FRIDAY *27*

SATURDAY *28*

Sierra Club founded, 1892

SUNDAY *29*

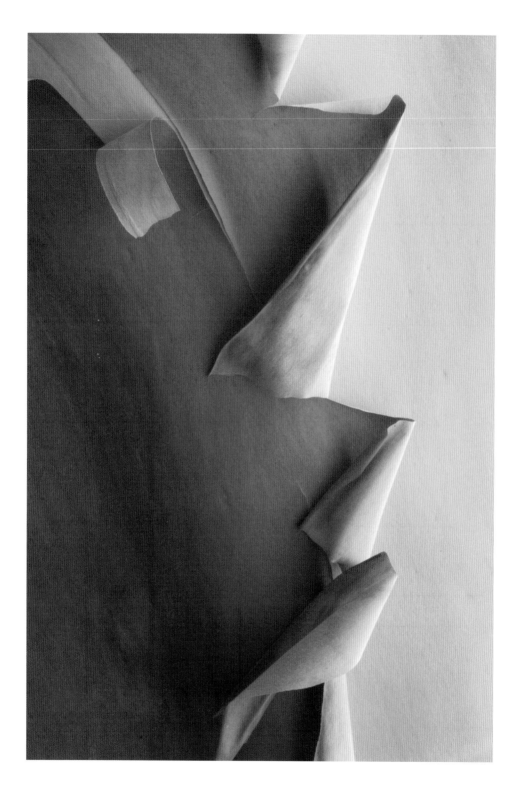

Pacific madrone tree bark, Whidbey Island, Washington.
PHOTO: TONY SWEET

JUNE

S	M	T	W	T	F	S
			1	2	3	4
5	6	7	8	9	10	11
12	13	14	15	16	17	18
19	20	21	22	23	24	25
26	27	28	29	30		

May
June

MONDAY *30*

Memorial Day

TUESDAY *31*

WEDNESDAY *1*

● NEW MOON

THURSDAY *2*

FRIDAY *3*

SATURDAY *4*

SUNDAY *5*

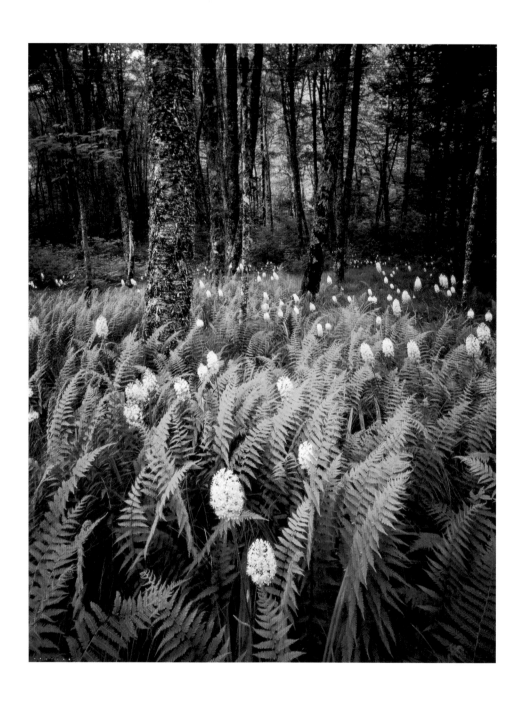

Fly-poison and ferns in birch forest, Great Smoky Mountains National Park, North Carolina.

JUNE

S	M	T	W	T	F	S
			1	2	3	4
5	6	7	8	9	10	11
12	13	14	15	16	17	18
19	20	21	22	23	24	25
26	27	28	29	30		

June

MONDAY *6*

TUESDAY *7*

WEDNESDAY *8*

◑ FIRST QUARTER

THURSDAY *9*

FRIDAY *10*

SATURDAY *11*

SUNDAY *12*

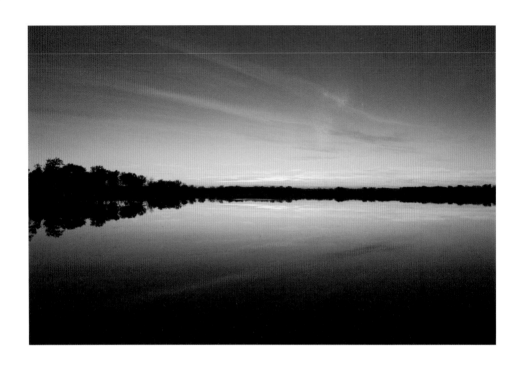

Evening clouds over Fish Lake, Cedar Creek Ecosystem Science Reserve, Minnesota.
PHOTO: GARY ALAN NELSON

JUNE

S	M	T	W	T	F	S
			1	2	3	4
5	6	7	8	9	10	11
12	13	14	15	16	17	18
19	20	21	22	23	24	25
26	27	28	29	30		

June

MONDAY *13*

TUESDAY *14*

WEDNESDAY *15*

○ FULL MOON

THURSDAY *16*

FRIDAY *17*

SATURDAY *18*

SUNDAY *19*

Father's Day

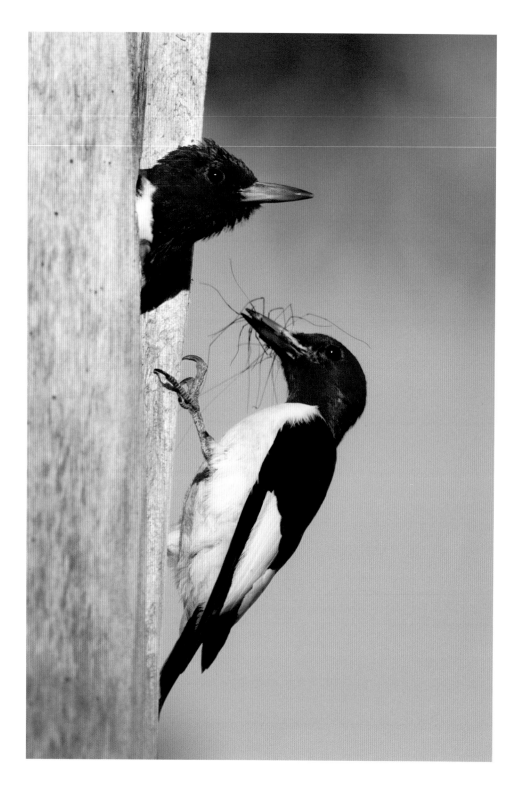

Redheaded woodpeckers, White Lake, Michigan.
PHOTO: PATRICK DENNEN

JUNE

S	M	T	W	T	F	S
			1	2	3	4
5	6	7	8	9	10	11
12	13	14	15	16	17	18
19	20	21	22	23	24	25
26	27	28	29	30		

June

MONDAY *20*

TUESDAY *21*

SOLSTICE

WEDNESDAY *22*

THURSDAY *23*

◑ LAST QUARTER

FRIDAY *24*

SATURDAY *25*

SUNDAY *26*

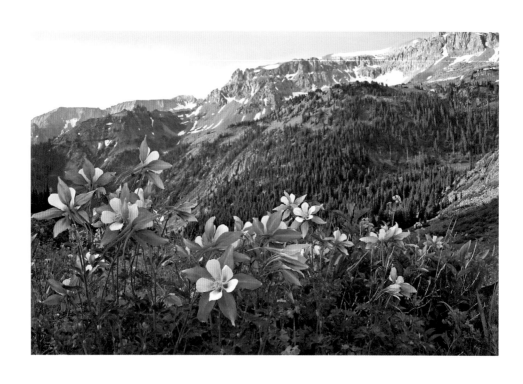

Colorado blue columbine, Yankee Boy Basin, Colorado.
PHOTO: VIC SCHENDEL

JULY

S	M	T	W	T	F	S
					1	2
3	4	5	6	7	8	9
10	11	12	13	14	15	16
17	18	19	20	21	22	23
24	25	26	27	28	29	30
31						

June
July

MONDAY 27

TUESDAY 28

WEDNESDAY 29

THURSDAY 30

FRIDAY 1

Canada Day
● NEW MOON

SATURDAY 2

SUNDAY 3

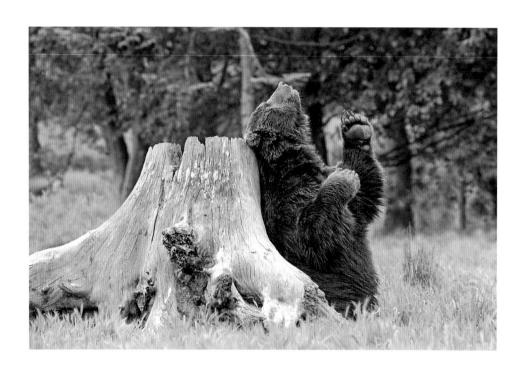

Brown bear, Kodiak Island, Alaska.
PHOTO: VIC SCHENDEL

J U L Y

S	M	T	W	T	F	S
					1	2
3	4	5	6	7	8	9
10	11	12	13	14	15	16
17	18	19	20	21	22	23
24	25	26	27	28	29	30
31						

July

MONDAY *4*

Independence Day

TUESDAY *5*

WEDNESDAY *6*

THURSDAY *7*

FRIDAY *8*

◑ FIRST QUARTER

SATURDAY *9*

SUNDAY *10*

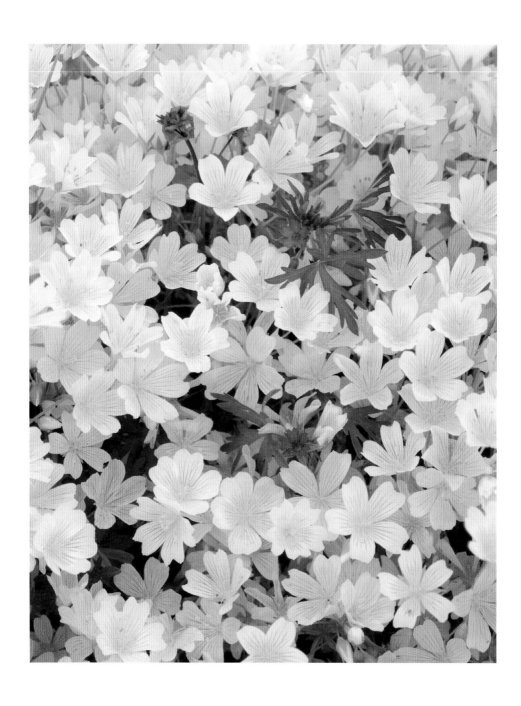

Meadowfoam and cutleaf geranium, Six Rivers National Forest, California.
PHOTO: SCOTT T. SMITH

J U L Y

S	M	T	W	T	F	S
					1	2
3	4	5	6	7	8	9
10	11	12	13	14	15	16
17	18	19	20	21	22	23
24	25	26	27	28	29	30
31						

July

MONDAY *11*

TUESDAY *12*

WEDNESDAY *13*

THURSDAY *14*

FRIDAY *15*

○ FULL MOON

SATURDAY *16*

SUNDAY *17*

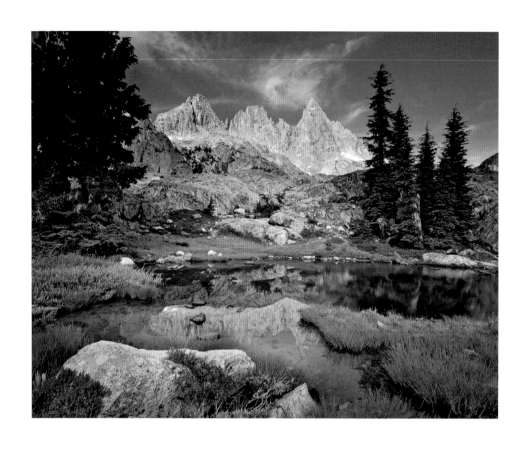

Minarets and Ritter Range, Ansel Adams Wilderness, California.

J U L Y

S	M	T	W	T	F	S
					1	2
3	4	5	6	7	8	9
10	11	12	13	14	15	16
17	18	19	20	21	22	23
24	25	26	27	28	29	30
31						

July

MONDAY *18*

TUESDAY *19*

WEDNESDAY *20*

THURSDAY *21*

FRIDAY *22*

SATURDAY *23*

◐ LAST QUARTER

SUNDAY *24*

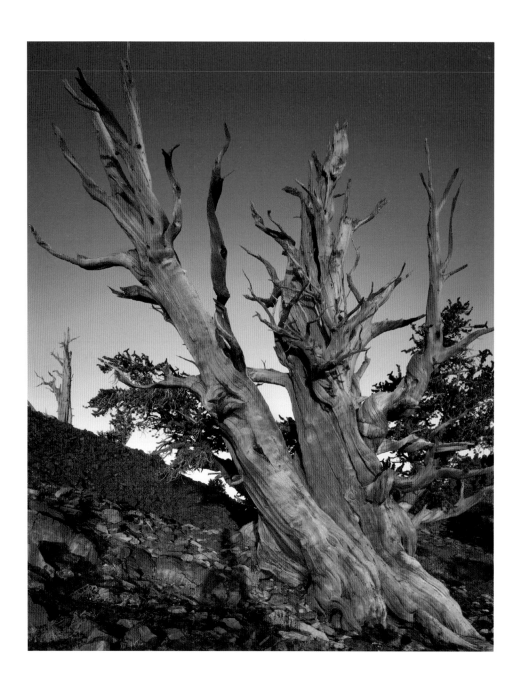

Ancient bristlecone pine at sunrise, White Mountains, Inyo National Forest, California.
PHOTO: GEORGE WARD

JULY

S	M	T	W	T	F	S
					1	2
3	4	5	6	7	8	9
10	11	12	13	14	15	16
17	18	19	20	21	22	23
24	25	26	27	28	29	30
31						

July

MONDAY *25*

TUESDAY *26*

WEDNESDAY *27*

THURSDAY *28*

FRIDAY *29*

SATURDAY *30*

● NEW MOON

SUNDAY *31*

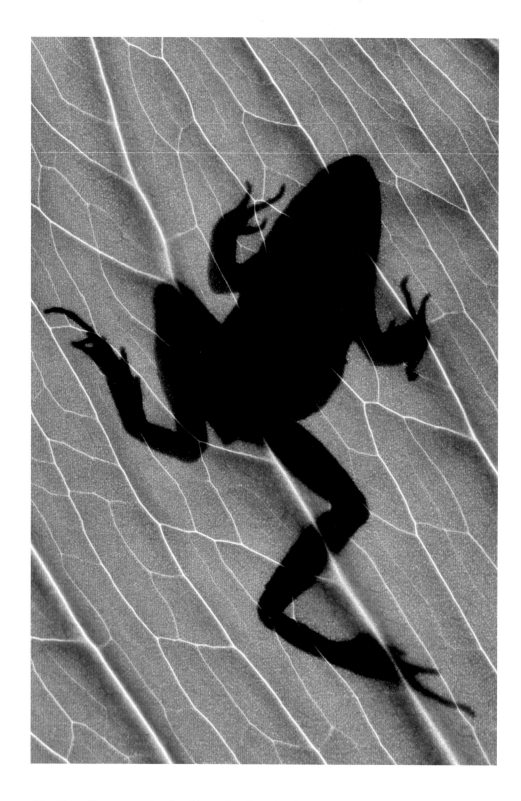

Wood frog silhouette on skunk cabbage, Brighton, Michigan.
PHOTO: STEVE GETTLE

	AUGUST					
S	M	T	W	T	F	S
	1	2	3	4	5	6
7	8	9	10	11	12	13
14	15	16	17	18	19	20
21	22	23	24	25	26	27
28	29	30	31			

August

MONDAY *1*

TUESDAY *2*

WEDNESDAY *3*

THURSDAY *4*

FRIDAY *5*

SATURDAY *6*

◗ FIRST QUARTER

SUNDAY *7*

Bottlebrush squirreltail grass, Denali National Park, Alaska.
PHOTO: JEFF VANUGA

AUGUST

S	M	T	W	T	F	S
	1	2	3	4	5	6
7	8	9	10	11	12	13
14	15	16	17	18	19	20
21	22	23	24	25	26	27
28	29	30	31			

August

MONDAY *8*

TUESDAY *9*

WEDNESDAY *10*

THURSDAY *11*

FRIDAY *12*

SATURDAY *13*

○ FULL MOON

SUNDAY *14*

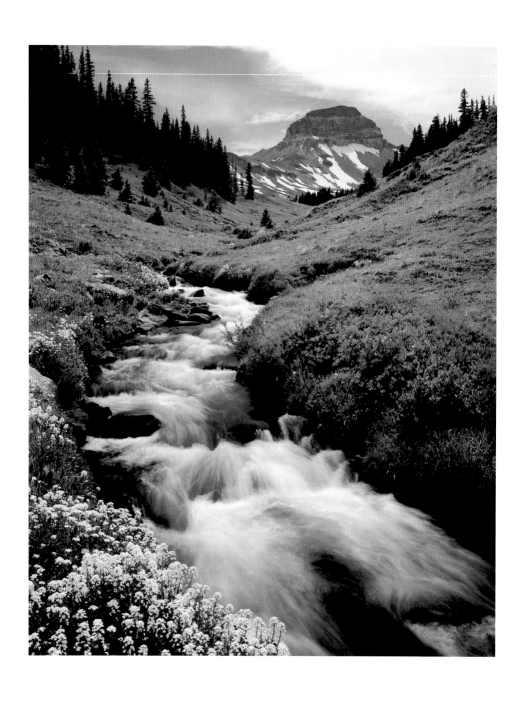

Uncompahgre Peak, Uncompahgre National Forest, Colorado.
PHOTO: ERIC WUNROW

AUGUST

S	M	T	W	T	F	S
	1	2	3	4	5	6
7	8	9	10	11	12	13
14	15	16	17	18	19	20
21	22	23	24	25	26	27
28	29	30	31			

August

MONDAY *15*

TUESDAY *16*

WEDNESDAY *17*

THURSDAY *18*

FRIDAY *19*

SATURDAY *20*

SUNDAY *21*

◑ LAST QUARTER

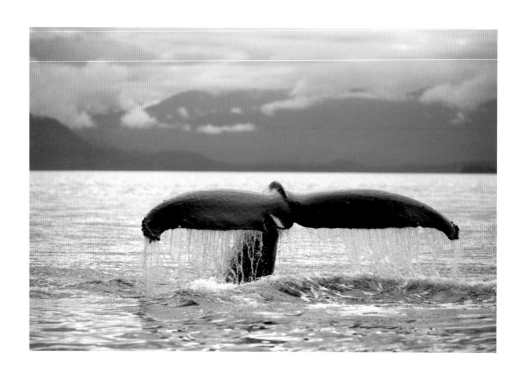

Humpback whale, Frederick Sound, Alaska.
PHOTO: JON CORNFORTH

AUGUST

S	M	T	W	T	F	S
	1	2	3	4	5	6
7	8	9	10	11	12	13
14	15	16	17	18	19	20
21	22	23	24	25	26	27
28	29	30	31			

August

MONDAY *22*

TUESDAY *23*

WEDNESDAY *24*

THURSDAY *25*

FRIDAY *26*

SATURDAY *27*

SUNDAY *28*

● NEW MOON

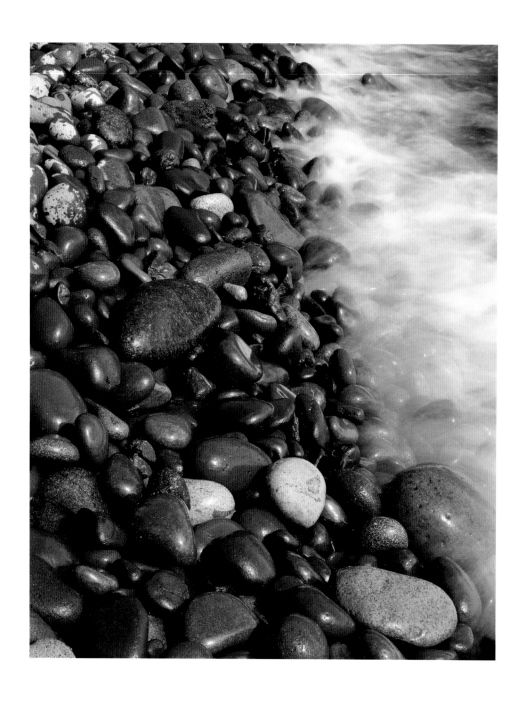

Cobble rocks, Lake Superior, Tettegouche State Park, Minnesota.
PHOTO: JOHN P. GEORGE

SEPTEMBER

S	M	T	W	T	F	S
				1	2	3
4	5	6	7	8	9	10
11	12	13	14	15	16	17
18	19	20	21	22	23	24
25	26	27	28	29	30	

August
September

MONDAY *29*

TUESDAY *30*

WEDNESDAY *31*

THURSDAY *1*

FRIDAY *2*

SATURDAY *3*

SUNDAY *4*

◑ FIRST QUARTER

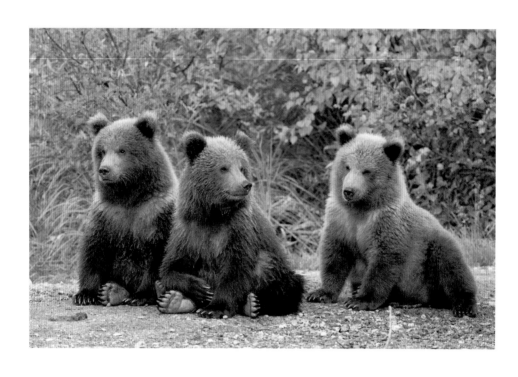

Brown bear cubs, Katmai National Park and Preserve, Alaska.
PHOTO: PATRICK J. ENDRES

SEPTEMBER

S	M	T	W	T	F	S
				1	2	3
4	5	6	7	8	9	10
11	12	13	14	15	16	17
18	19	20	21	22	23	24
25	26	27	28	29	30	

September

MONDAY 5

Labor Day

TUESDAY 6

WEDNESDAY 7

THURSDAY 8

FRIDAY 9

SATURDAY 10

SUNDAY 11

Frosty leaf with Chinese lanterns, White Lake, Michigan.
PHOTO: PATRICK DENNEN

SEPTEMBER
S M T W T F S
1 2 3
4 5 6 7 8 9 10
11 12 13 14 15 16 17
18 19 20 21 22 23 24
25 26 27 28 29 30

September

MONDAY *12*

○ FULL MOON

TUESDAY *13*

WEDNESDAY *14*

THURSDAY *15*

FRIDAY *16*

SATURDAY *17*

SUNDAY *18*

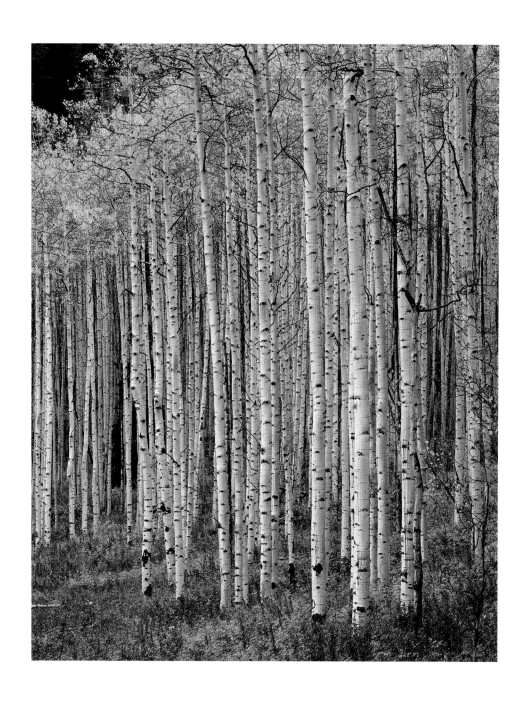

Aspens in autumn, White River National Forest, Colorado.
PHOTO: CARR CLIFTON

SEPTEMBER

S	M	T	W	T	F	S
				1	2	3
4	5	6	7	8	9	10
11	12	13	14	15	16	17
18	19	20	21	22	23	24
25	26	27	28	29	30	

September

MONDAY *19*

TUESDAY *20*

◑ LAST QUARTER

WEDNESDAY *21*

THURSDAY *22*

FRIDAY *23*

EQUINOX

SATURDAY *24*

SUNDAY *25*

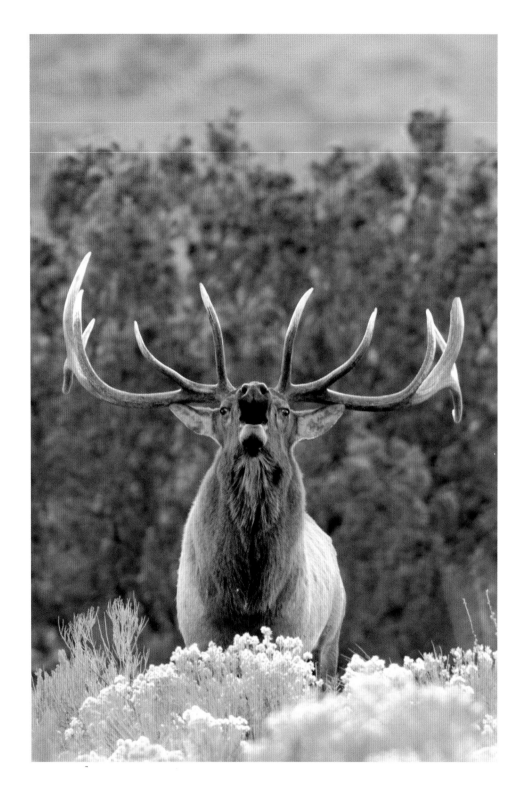

Bull elk, Yellowstone National Park, Wyoming.
PHOTO: PATRICK DENNEN

OCTOBER

S	M	T	W	T	F	S
						1
2	3	4	5	6	7	8
9	10	11	12	13	14	15
16	17	18	19	20	21	22
23	24	25	26	27	28	29
30	31					

September
October

MONDAY *26*

TUESDAY *27*

● NEW MOON

WEDNESDAY *28*

THURSDAY *29*

Rosh Hashanah

FRIDAY *30*

SATURDAY *1*

SUNDAY *2*

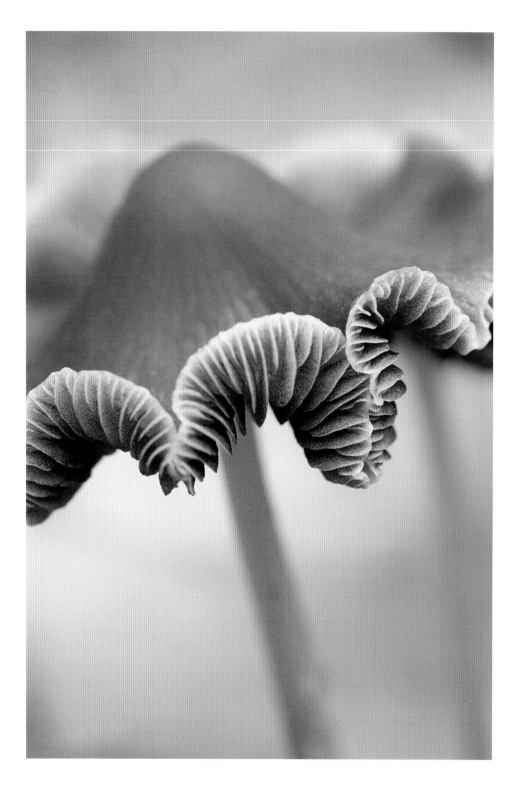

Mycena mushroom, Columbia River Gorge National Scenic Area, Oregon.
PHOTO: DAVID COBB

OCTOBER

S	M	T	W	T	F	S
						1
2	3	4	5	6	7	8
9	10	11	12	13	14	15
16	17	18	19	20	21	22
23	24	25	26	27	28	29
30	31					

October

MONDAY 3

◗ FIRST QUARTER

TUESDAY 4

WEDNESDAY 5

THURSDAY 6

FRIDAY 7

SATURDAY 8

Yom Kippur

SUNDAY 9

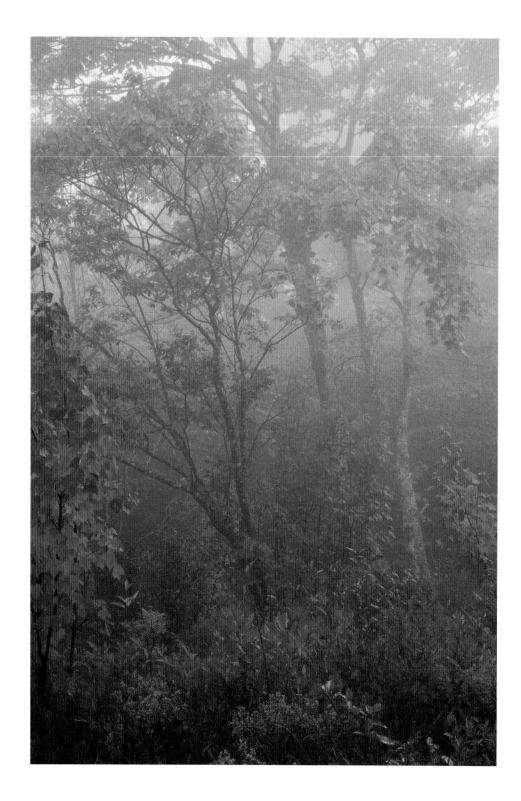

Fall foliage, Graveyard Fields, Pisgah National Forest, North Carolina.
PHOTO: ROGER CANADA

O C T O B E R

S	M	T	W	T	F	S
						1
2	3	4	5	6	7	8
9	10	11	12	13	14	15
16	17	18	19	20	21	22
23	24	25	26	27	28	29
30	31					

October

MONDAY *10*

Columbus Day
Thanksgiving (Canada)

TUESDAY *11*

○ FULL MOON

WEDNESDAY *12*

THURSDAY *13*

FRIDAY *14*

SATURDAY *15*

SUNDAY *16*

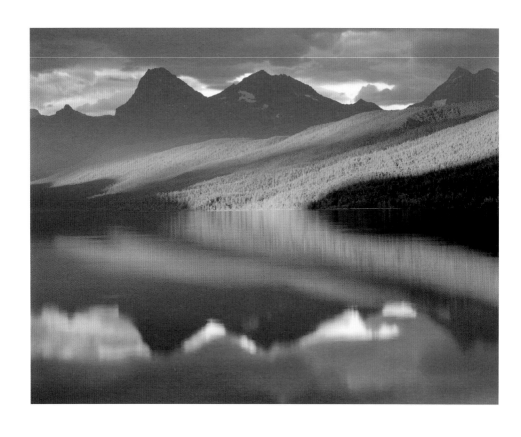

Evening reflections on Lake McDonald, Glacier National Park, Montana.
PHOTO: TOM TILL

OCTOBER

S	M	T	W	T	F	S
						1
2	3	4	5	6	7	8
9	10	11	12	13	14	15
16	17	18	19	20	21	22
23	24	25	26	27	28	29
30	31					

October

MONDAY 17

TUESDAY 18

WEDNESDAY 19

◑ LAST QUARTER

THURSDAY 20

FRIDAY 21

SATURDAY 22

SUNDAY 23

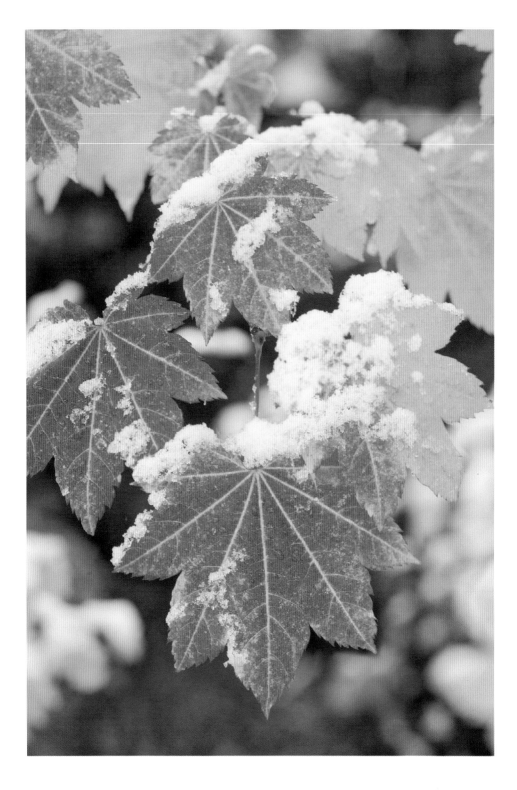

Vine maple leaves and snow, Mt. Hood National Forest, Oregon.
PHOTO: DAN SHERWOOD

O C T O B E R

S	M	T	W	T	F	S
						1
2	3	4	5	6	7	8
9	10	11	12	13	14	15
16	17	18	19	20	21	22
23	24	25	26	27	28	29
30	31					

October

MONDAY *24*

TUESDAY *25*

WEDNESDAY *26*

● NEW MOON

THURSDAY *27*

FRIDAY *28*

SATURDAY *29*

SUNDAY *30*

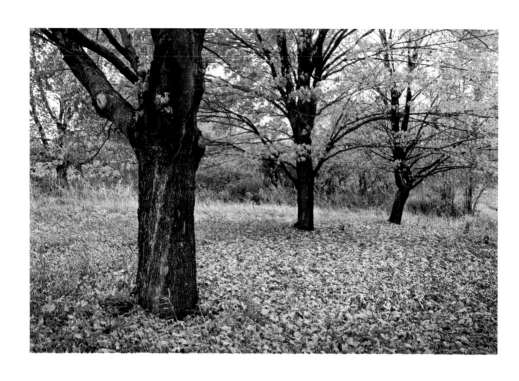

Maple trees, Douglas County, Kansas.
PHOTO: EDWARD C. ROBISON III

NOVEMBER

S	M	T	W	T	F	S
		1	2	3	4	5
6	7	8	9	10	11	12
13	14	15	16	17	18	19
20	21	22	23	24	25	26
27	28	29	30			

October
November

MONDAY 31

Halloween

TUESDAY 1

WEDNESDAY 2

◑ FIRST QUARTER

THURSDAY 3

FRIDAY 4

SATURDAY 5

SUNDAY 6

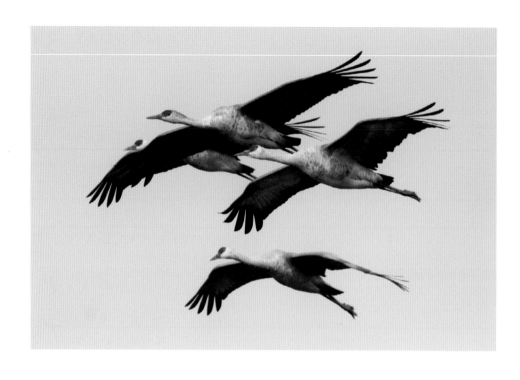

Lesser sandhill cranes, San Joaquin County, California.
PHOTO: RON WOLF/TOM STACK & ASSOCIATES

NOVEMBER

S	M	T	W	T	F	S
		1	2	3	4	5
6	7	8	9	10	11	12
13	14	15	16	17	18	19
20	21	22	23	24	25	26
27	28	29	30			

November

MONDAY 7

TUESDAY 8

Election Day

WEDNESDAY 9

THURSDAY 10

○ FULL MOON

FRIDAY 11

Veterans Day

SATURDAY 12

SUNDAY 13

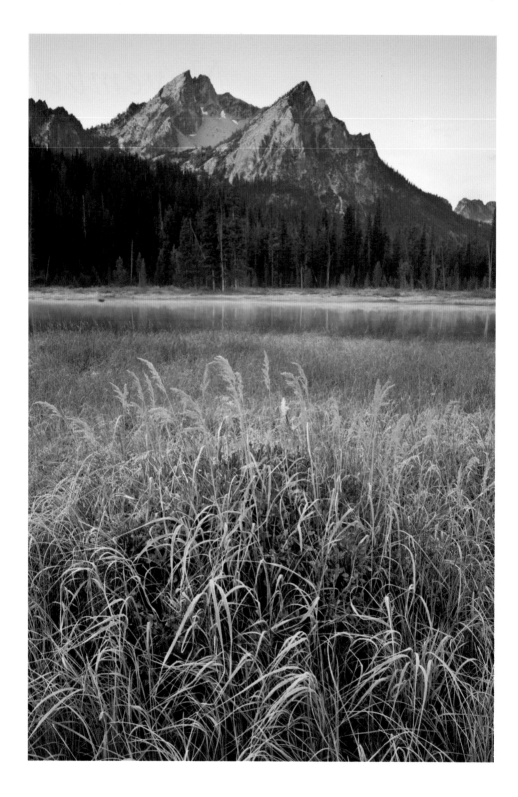

McGown Peak at sunrise, Sawtooth National Forest, Idaho.
PHOTO: DAVID COBB

NOVEMBER

S	M	T	W	T	F	S
		1	2	3	4	5
6	7	8	9	10	11	12
13	14	15	16	17	18	19
20	21	22	23	24	25	26
27	28	29	30			

November

MONDAY 14

TUESDAY 15

WEDNESDAY 16

THURSDAY 17

FRIDAY 18

◑ LAST QUARTER

SATURDAY 19

SUNDAY 20

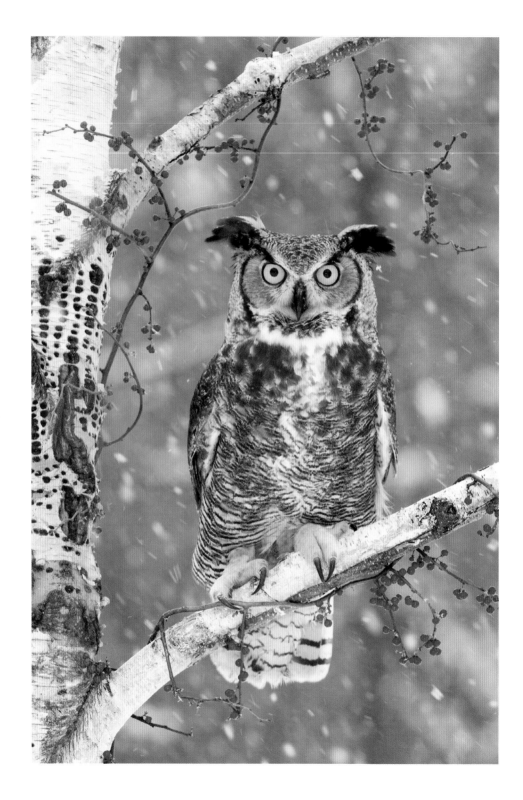

Great horned owl framed by bittersweet, Howell, Michigan.
PHOTO: STEVE GETTLE

NOVEMBER

S	M	T	W	T	F	S
		1	2	3	4	5
6	7	8	9	10	11	12
13	14	15	16	17	18	19
20	21	22	23	24	25	26
27	28	29	30			

November

MONDAY *21*

TUESDAY *22*

WEDNESDAY *23*

THURSDAY *24*

Thanksgiving (USA)

FRIDAY *25*

● NEW MOON

SATURDAY *26*

SUNDAY *27*

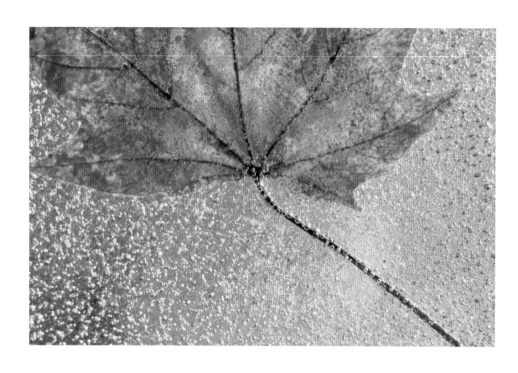

Maple leaf encased in ice, Laurelhurst Park, Portland, Oregon.
PHOTO: DAN SHERWOOD

DECEMBER

S	M	T	W	T	F	S
				1	2	3
4	5	6	7	8	9	10
11	12	13	14	15	16	17
18	19	20	21	22	23	24
25	26	27	28	29	30	31

November
December

MONDAY 28

TUESDAY 29

WEDNESDAY 30

THURSDAY 1

FRIDAY 2

◑ FIRST QUARTER

SATURDAY 3

SUNDAY 4

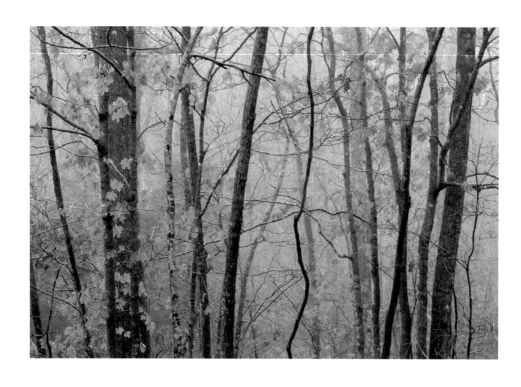

Maple trees in fog, Carroll County, Arkansas.
PHOTO: EDWARD C. ROBISON III

DECEMBER

S	M	T	W	T	F	S
				1	2	3
4	5	6	7	8	9	10
11	12	13	14	15	16	17
18	19	20	21	22	23	24
25	26	27	28	29	30	31

December

MONDAY 5

TUESDAY 6

WEDNESDAY 7

THURSDAY 8

FRIDAY 9

SATURDAY 10

○ FULL MOON
TOTAL LUNAR ECLIPSE, 9:32 A.M.

SUNDAY 11

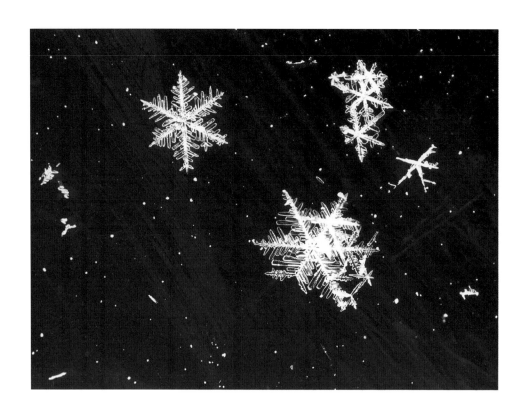

Snowflakes, Delta Junction, Alaska.
PHOTO: PATRICK J. ENDRES

DECEMBER

S	M	T	W	T	F	S
				1	2	3
4	5	6	7	8	9	10
11	12	13	14	15	16	17
18	19	20	21	22	23	24
25	26	27	28	29	30	31

December

MONDAY *12*

TUESDAY *13*

WEDNESDAY *14*

THURSDAY *15*

FRIDAY *16*

SATURDAY *17*

◑ LAST QUARTER

SUNDAY *18*

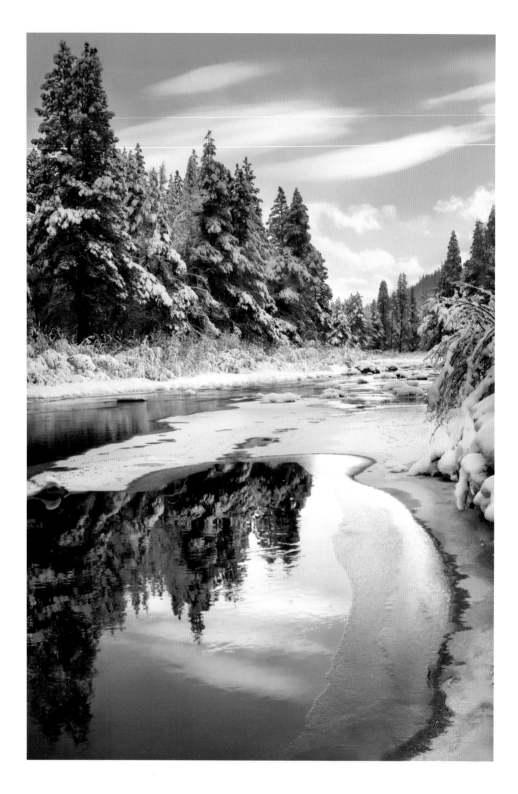

Truckee River in winter, Tahoe National Forest, California.
PHOTO: ELIZABETH CARMEL

DECEMBER

S	M	T	W	T	F	S
				1	2	3
4	5	6	7	8	9	10
11	12	13	14	15	16	17
18	19	20	21	22	23	24
25	26	27	28	29	30	31

December

MONDAY *19*

TUESDAY *20*

WEDNESDAY *21*

Hanukkah

THURSDAY *22*

SOLSTICE

FRIDAY *23*

SATURDAY *24*

● NEW MOON

SUNDAY *25*

Christmas

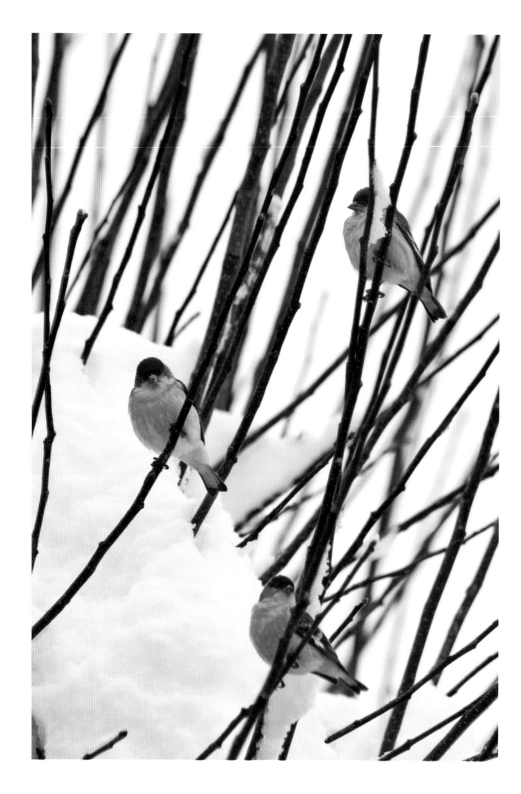

Lesser goldfinches, Mono Lake, Mono Basin National Forest Scenic Area, California.
PHOTO: DAN BLACKBURN

JANUARY
S M T W T F S
1 2 3 4 5 6 7
8 9 10 11 12 13 14
15 16 17 18 19 20 21
22 23 24 25 26 27 28
29 30 31

December
January

MONDAY 26

Boxing Day (Canada)
Kwanzaa

TUESDAY 27

WEDNESDAY 28

THURSDAY 29

FRIDAY 30

SATURDAY 31

SUNDAY 1

New Year's Day

2010

JANUARY
S	M	T	W	T	F	S
					1	2
3	4	5	6	7	8	9
10	11	12	13	14	15	16
17	18	19	20	21	22	23
24	25	26	27	28	29	30
31						

FEBRUARY
S	M	T	W	T	F	S
	1	2	3	4	5	6
7	8	9	10	11	12	13
14	15	16	17	18	19	20
21	22	23	24	25	26	27
28						

MARCH
S	M	T	W	T	F	S
	1	2	3	4	5	6
7	8	9	10	11	12	13
14	15	16	17	18	19	20
21	22	23	24	25	26	27
28	29	30	31			

APRIL
S	M	T	W	T	F	S
				1	2	3
4	5	6	7	8	9	10
11	12	13	14	15	16	17
18	19	20	21	22	23	24
25	26	27	28	29	30	

MAY
S	M	T	W	T	F	S
						1
2	3	4	5	6	7	8
9	10	11	12	13	14	15
16	17	18	19	20	21	22
23	24	25	26	27	28	29
30	31					

JUNE
S	M	T	W	T	F	S
		1	2	3	4	5
6	7	8	9	10	11	12
13	14	15	16	17	18	19
20	21	22	23	24	25	26
27	28	29	30			

JULY
S	M	T	W	T	F	S
				1	2	3
4	5	6	7	8	9	10
11	12	13	14	15	16	17
18	19	20	21	22	23	24
25	26	27	28	29	30	31

AUGUST
S	M	T	W	T	F	S
1	2	3	4	5	6	7
8	9	10	11	12	13	14
15	16	17	18	19	20	21
22	23	24	25	26	27	28
29	30	31				

SEPTEMBER
S	M	T	W	T	F	S
			1	2	3	4
5	6	7	8	9	10	11
12	13	14	15	16	17	18
19	20	21	22	23	24	25
26	27	28	29	30		

OCTOBER
S	M	T	W	T	F	S
					1	2
3	4	5	6	7	8	9
10	11	12	13	14	15	16
17	18	19	20	21	22	23
24	25	26	27	28	29	30
31						

NOVEMBER
S	M	T	W	T	F	S
	1	2	3	4	5	6
7	8	9	10	11	12	13
14	15	16	17	18	19	20
21	22	23	24	25	26	27
28	29	30				

DECEMBER
S	M	T	W	T	F	S
			1	2	3	4
5	6	7	8	9	10	11
12	13	14	15	16	17	18
19	20	21	22	23	24	25
26	27	28	29	30	31	

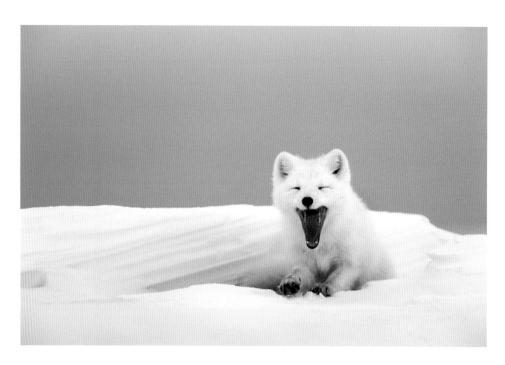

Arctic fox on snowdrift, Brooks Range, Alaska.

PHOTO: PATRICK J. ENDRES

2011

JANUARY
S	M	T	W	T	F	S
						1
2	3	4	5	6	7	8
9	10	11	12	13	14	15
16	17	18	19	20	21	22
23	24	25	26	27	28	29
30	31					

FEBRUARY
S	M	T	W	T	F	S
		1	2	3	4	5
6	7	8	9	10	11	12
13	14	15	16	17	18	19
20	21	22	23	24	25	26
27	28					

MARCH
S	M	T	W	T	F	S
		1	2	3	4	5
6	7	8	9	10	11	12
13	14	15	16	17	18	19
20	21	22	23	24	25	26
27	28	29	30	31		

APRIL
S	M	T	W	T	F	S
					1	2
3	4	5	6	7	8	9
10	11	12	13	14	15	16
17	18	19	20	21	22	23
24	25	26	27	28	29	30

MAY
S	M	T	W	T	F	S
1	2	3	4	5	6	7
8	9	10	11	12	13	14
15	16	17	18	19	20	21
22	23	24	25	26	27	28
29	30	31				

JUNE
S	M	T	W	T	F	S
			1	2	3	4
5	6	7	8	9	10	11
12	13	14	15	16	17	18
19	20	21	22	23	24	25
26	27	28	29	30		

JULY
S	M	T	W	T	F	S
					1	2
3	4	5	6	7	8	9
10	11	12	13	14	15	16
17	18	19	20	21	22	23
24	25	26	27	28	29	30
31						

AUGUST
S	M	T	W	T	F	S
	1	2	3	4	5	6
7	8	9	10	11	12	13
14	15	16	17	18	19	20
21	22	23	24	25	26	27
28	29	30	31			

SEPTEMBER
S	M	T	W	T	F	S
				1	2	3
4	5	6	7	8	9	10
11	12	13	14	15	16	17
18	19	20	21	22	23	24
25	26	27	28	29	30	

OCTOBER
S	M	T	W	T	F	S
						1
2	3	4	5	6	7	8
9	10	11	12	13	14	15
16	17	18	19	20	21	22
23	24	25	26	27	28	29
30	31					

NOVEMBER
S	M	T	W	T	F	S
		1	2	3	4	5
6	7	8	9	10	11	12
13	14	15	16	17	18	19
20	21	22	23	24	25	26
27	28	29	30			

DECEMBER
S	M	T	W	T	F	S
				1	2	3
4	5	6	7	8	9	10
11	12	13	14	15	16	17
18	19	20	21	22	23	24
25	26	27	28	29	30	31

2012

JANUARY
S	M	T	W	T	F	S
1	2	3	4	5	6	7
8	9	10	11	12	13	14
15	16	17	18	19	20	21
22	23	24	25	26	27	28
29	30	31				

FEBRUARY
S	M	T	W	T	F	S
			1	2	3	4
5	6	7	8	9	10	11
12	13	14	15	16	17	18
19	20	21	22	23	24	25
26	27	28	29			

MARCH
S	M	T	W	T	F	S
				1	2	3
4	5	6	7	8	9	10
11	12	13	14	15	16	17
18	19	20	21	22	23	24
25	26	27	28	29	30	31

APRIL
S	M	T	W	T	F	S
1	2	3	4	5	6	7
8	9	10	11	12	13	14
15	16	17	18	19	20	21
22	23	24	25	26	27	28
29	30					

MAY
S	M	T	W	T	F	S
		1	2	3	4	5
6	7	8	9	10	11	12
13	14	15	16	17	18	19
20	21	22	23	24	25	26
27	28	29	30	31		

JUNE
S	M	T	W	T	F	S
					1	2
3	4	5	6	7	8	9
10	11	12	13	14	15	16
17	18	19	20	21	22	23
24	25	26	27	28	29	30

JULY
S	M	T	W	T	F	S
1	2	3	4	5	6	7
8	9	10	11	12	13	14
15	16	17	18	19	20	21
22	23	24	25	26	27	28
29	30	31				

AUGUST
S	M	T	W	T	F	S
			1	2	3	4
5	6	7	8	9	10	11
12	13	14	15	16	17	18
19	20	21	22	23	24	25
26	27	28	29	30	31	

SEPTEMBER
S	M	T	W	T	F	S
						1
2	3	4	5	6	7	8
9	10	11	12	13	14	15
16	17	18	19	20	21	22
23	24	25	26	27	28	29
30						

OCTOBER
S	M	T	W	T	F	S
	1	2	3	4	5	6
7	8	9	10	11	12	13
14	15	16	17	18	19	20
21	22	23	24	25	26	27
28	29	30	31			

NOVEMBER
S	M	T	W	T	F	S
				1	2	3
4	5	6	7	8	9	10
11	12	13	14	15	16	17
18	19	20	21	22	23	24
25	26	27	28	29	30	

DECEMBER
S	M	T	W	T	F	S
						1
2	3	4	5	6	7	8
9	10	11	12	13	14	15
16	17	18	19	20	21	22
23	24	25	26	27	28	29
30	31					

Offices of the Sierra Club

National Offices

Sierra Club Headquarters
85 Second Street
San Francisco, CA 94105
(415) 977-5500

Sierra Club Legislative
Office
408 C Street NE
Washington, DC 20002
(202) 547-1141

The Sierra Club Foundation
85 Second Street, Suite 750
San Francisco, CA 94105
(415) 995-1780

Sierra Club Canada
1 Nicholas Street, Suite 412
Ottawa, Ontario
Canada K1N 7B7
(613) 241-4611

Sierra Student Coalition
600 14th Street NW,
Suite 750
Washington, DC 20005
(888) JOIN-SSC
(888-564-6772)

Regional Offices

Sierra Club Western
Regional Office
45 E. Loucks, #109
Sheridan, WY 82801
(307) 672-0425

Sierra Club Central
Regional Office
400 W. Front Street,
Suite 204
Traverse City, MI 49684
(231) 922-2201

Sierra Club Eastern
Regional Office
1133 15th Street NW,
Suite 1075
Washington, DC 20005
(202) 547-1141

Addresses may change. Please note that this list does not include any of the chapters or local groups throughout the United States. For information and addresses, write to Sierra Club, 85 Second Street, San Francisco, CA 94105; call (415) 977-5500; or visit www.sierraclub.org.

Notes

Notes

Notes

Notes

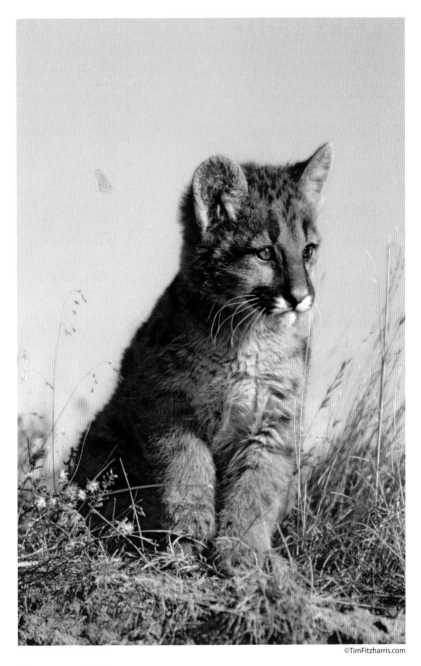

©TimFitzharris.com

For over 100 years, Sierra Club has been preserving and protecting the environment. Our planet is changing rapidly, and if we want the world's wildlife and native plants to survive in a changing climate, we must help them adapt by protecting critical habitat and creating corridors that will allow for migration as climate changes and temperatures rise. Help us support resiliant habitats so that our wild lands and wildlife may survive and prosper.

Join Sierra Club today.

SIERRA
CLUB
FOUNDED 1892

MEMBERSHIP FORM

☐ *YES!* *I want to be a member of the Sierra Club and help preserve the beauty of the Earth.*

MY NAME

ADDRESS

CITY STATE ZIP

HOME PHONE

E-MAIL ADDRESS

☐ *From time to time, we make our mailing list available to other worthy organizations. If you prefer that your name not be included, please check here.*

*Special Offer!**

FREE Sierra Club Voyager Duffel Bag with your membership!

Membership Categories

(CHECK ONE)	Individual	Joint
SPECIAL OFFER*	☐ $25	
REGULAR	☐ $39	☐ $49

Payment Method:

☐ Check ☐ VISA ☐ MasterCard ☐ AMEX

CARDHOLDER NAME

CARD NUMBER

EXPIRATION DATE

Contributions, gifts, and dues to the Sierra Club are not tax-deductible; they support our effective, citizen-based advocacy and lobbying efforts. Your dues include $7.50 for a subscription to *Sierra* magazine and $1.00 for your Chapter newsletter.

Enclose payment information and mail to: 　J11QCLT002

SIERRA CLUB
P.O. Box 421041, Palm Coast, FL 32142-6417

To join Sierra Club of Canada,
go to: www.sierraclub.ca

SIERRA CLUB
FOUNDED 1892

Explore, enjoy and protect the planet

BENEFITS

You'll Be Helping the Planet

You'll have the satisfaction of helping preserve irreplaceable wild lands and wildlife. Your voice will be heard through congressional lobbying and grassroots action.

SIERRA Magazine

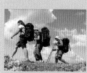

You'll stay well informed with a one-year subscripti to award-winning *SIERR* magazine—filled with spectacular nature photography and in-depth reporting on t hottest environmental issues.

Discounts

Your membership entitles you to discount on selected Sierra Club logo items. You'll also receive discounts on our distinguished books and celebrated calendars. Visit the Sierra Club store: www.sierraclub.org/stor

Worldwide Outings Program

Each year Sierra Club Outings offers thousands of adventure trips around the world. Join us to trek in the Himalayas, walk across the U.K., snorkel in Belize, backpack California's Sierra Nevada, participate in a service trip in the Southwest, kayak throug Florida, explore the remote beauty of Alaska and much more. For further details, visit: www.sierraclub.org/outings/national.

Local Chapter Membership

You'll receive up-to-date news on local conservation issues, plus invitations to Chapter events. You can also volunteer for local or national conservation campaigns.

 Recycled Paper